THE
BIG
PICTURE

ANDREW KALITKA

WINEPRESS WP PUBLISHING

Printed in South Korea

Published by WinePress Publishing, PO Box 428, Enumclaw, WA 98022. The views expressed or implied in this work do not necessarily reflect those of WinePress Publishing. Ultimate design, content, and editorial accuracy of this work is the responsibility of the author(s).

Unless otherwise noted all scriptures are taken from the Holy Bible, New International Version, Copyright © 1973, 1978, 1984 by the International Bible Society. Used by permission of Zondervan Publishing House. The "NIV" and "New International Version" trademarks are registered in the United States Patent and Trademark Office by International Bible Society.

ISBN 1-57921-262-X
Library of Congress Catalog Card Number: 99-68185

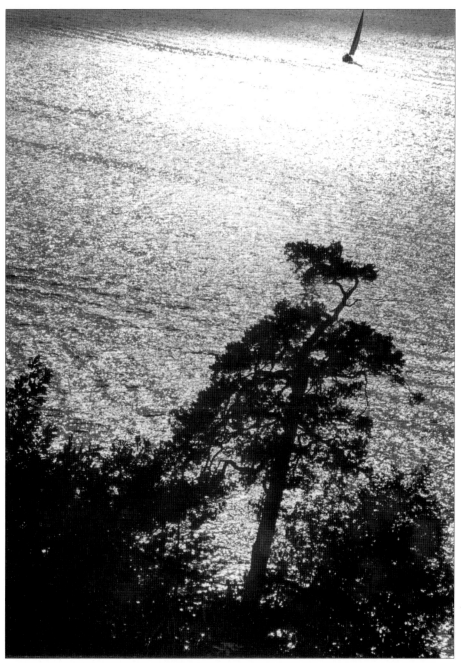

"My son, give me your heart, and let your eyes observe my ways."
Proverbs 23:26 NKJV

DEDICATION

To my late father, Peter, and my late stepfather, Richard.
Both of them had a huge impact on my life.

ACKNOWLEDGMENTS

First, I would like to thank Chuck and Athena Dean, as well as Tammy Hopf and the rest of the staff at WinePress. Without them, this book might have never been published.

Also, thank you to all of my friends and teachers who gave feedback and suggestions while I was revising this book. I would especially like to thank John Eldredge, Larry Burtoft, Hobert Farrell, Angie Boling, Matt Eaton, Jason Bull, Ken Lawson, Dante Rosso, and Karen Holmes.

I would also like to thank Mike Rosebush and the rest of the teachers and staff at Focus on the Family Institute. During my semester of studies there, they provided the love and support necessary for me to pursue my dreams.

Last, I would like to thank my mother, Mary Hovey, for her support as I worked on this book.

INTRODUCTION

Beauty and knowledge go together. We can take in beauty however we choose, feeling the different emotions that each object can evoke in us, yet we cannot escape the fact that each beautiful object exists both objectively and subjectively. Otherwise, there would be nothing beautiful to have feelings about.

The items that seem so beautiful to us can be scientifically analyzed, just like the dullest mound of dirt. Yet, some things are exquisitely beautiful, and other things are dull or even ugly. There is something about beautiful things that evokes curiosity and worship within us.

The existence of beauty in the objective, physical world indicates that design is involved. Many of the colors and shapes that we find so beautiful serve no evolutionary purpose. This suggests that maybe a Creator who loves beauty designed both the world and the people who enjoy its beauty.

There are several passages in the Bible that mention both the beauty of the earth and the personal, holy nature of our Creator God. In these passages, beauty and knowledge of God go hand in hand. In this book, I offer an exercise for the heart, soul, and mind of you, the reader, by encouraging you to see God's grace, goodness, and holiness within and through the beauty around us. Try to gain new insights about God by relating the beauty that you see in the photographs to the depiction of God that exists in the Scripture passages. Pray about it. Perhaps you will look at the world in a much different way once your love for beauty and your love for God become more clearly intertwined.

PART ONE

A CREATOR WHO LOVES BEAUTY AND A CREATION THAT LOVES IT, TOO

There is natural beauty everywhere in the world. Even in the deserts, flowers bloom. In the deepest, darkest parts of the sea, the fish contain magnificent color. Everything in nature is nothing short of a special creation, and the Creator of it all seems to love beauty. Human beings, being able to enjoy the same beauty that the Creator enjoys, must have a very special place in the Creator's heart, and must be a very special part of the Creation.

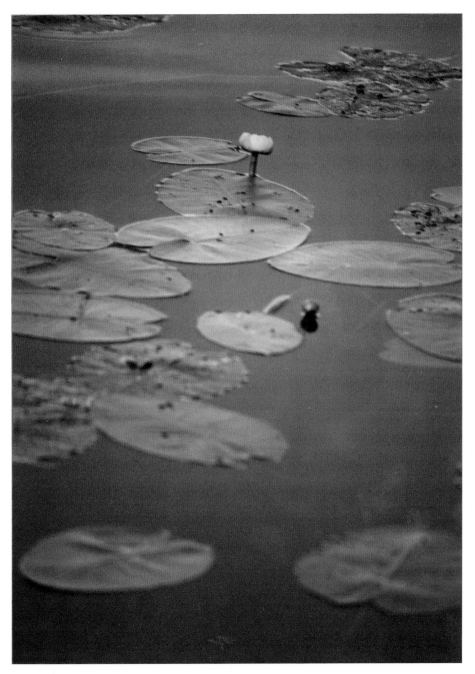

Stafsjo, Sweden

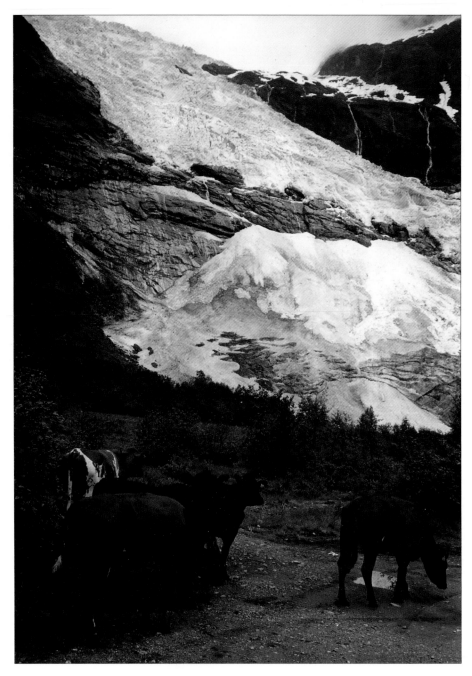

Boeya glacier, Norway

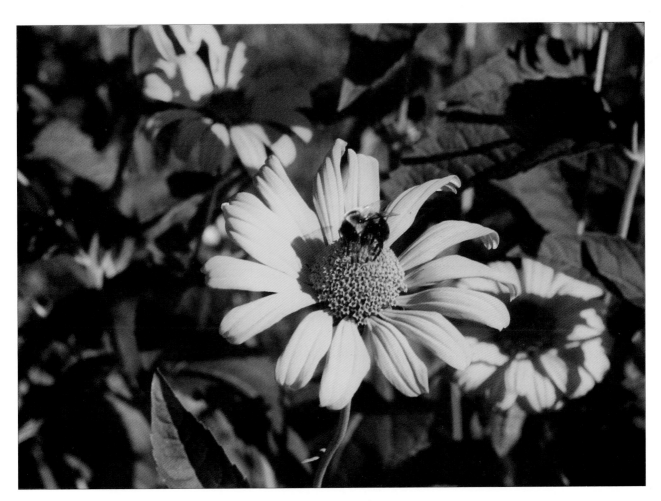

Magnolia, Massachusetts

Munsinger Gardens, St. Cloud, Minnesota

Estes Park, Colorado

Garden of the Gods, Colorado Springs, Colorado

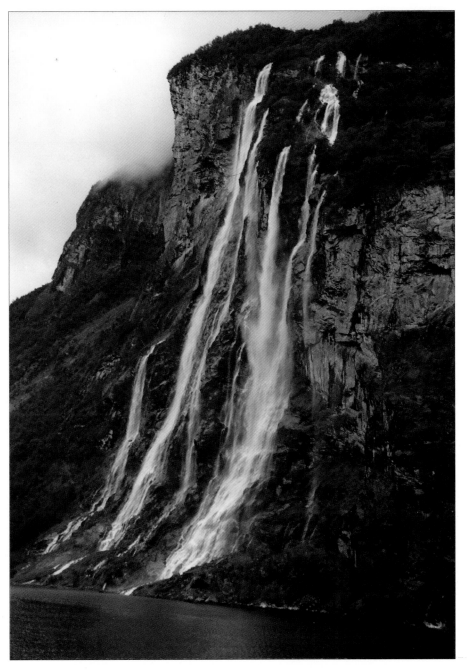

Seven Sisters waterfall, Geirangerfjord, Norway

Green Pond, Gainesville, Florida

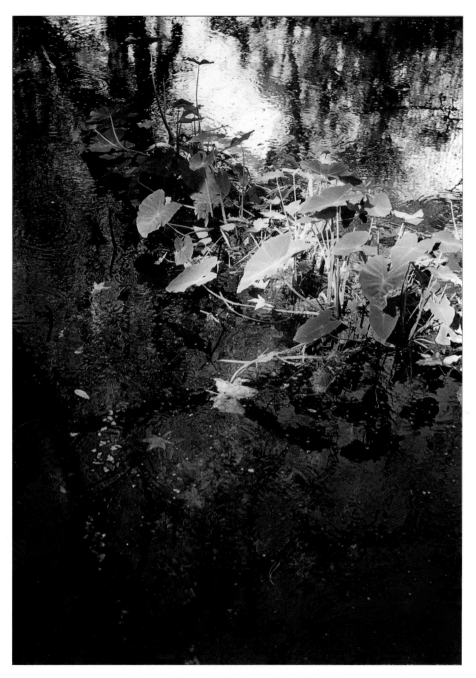

Green Pond, Gainesville, Florida

And God said, "Let the water teem with living creatures, and let birds fly above the earth across the expanse of the sky." So God created the great creatures of the sea and every living and moving thing with which the water teems, according to their kinds, and every winged bird according to its kind. And God saw that it was good. God blessed them and said, "Be fruitful and increase in number and fill the water in the seas, and let the birds increase on the earth." And there was evening and there was morning—the fifth day (Genesis 1:20–23, NIV).

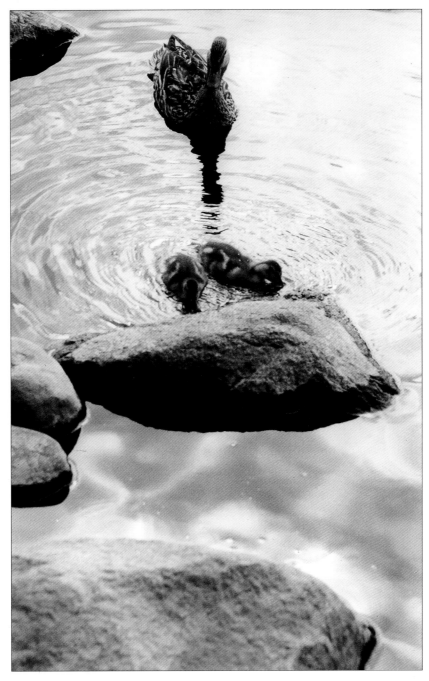

Mississippi River, St. Cloud, Minnesota

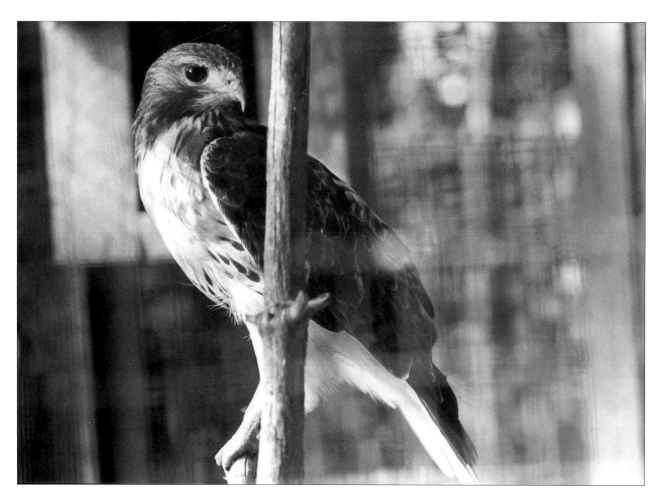

Essex, Massachusetts

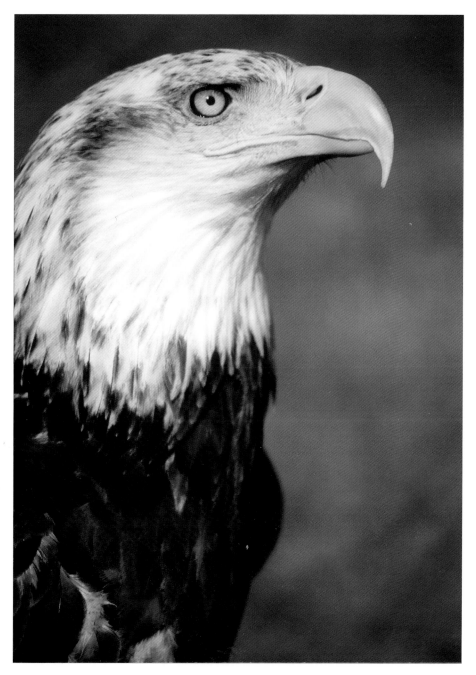

Southern Oregon

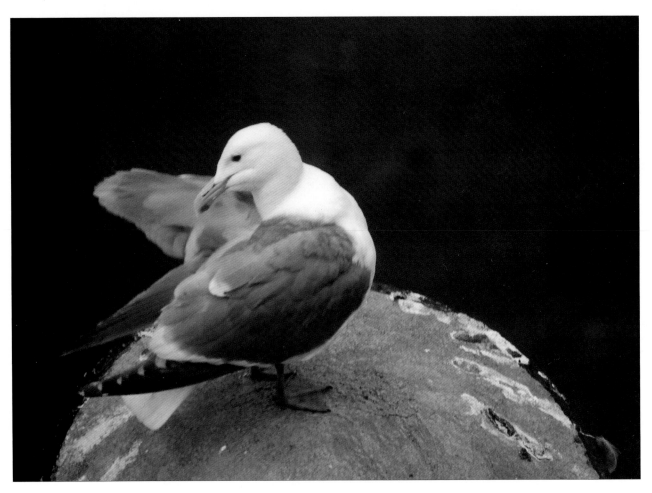

Seattle, Washington

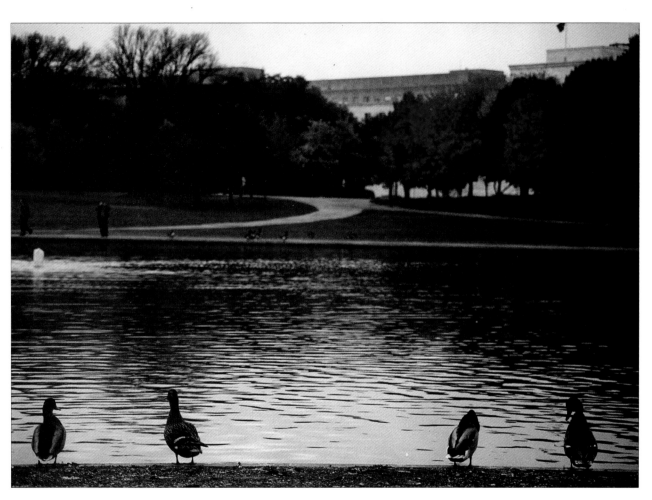

Reflecting Pool, Washington, D.C.

Then God said, "Let us make man in our image, in our likeness, and let them rule over the fish of the sea and the birds of the air, over the livestock, over all the earth, and over all the creatures that move along the ground." So God created man in his own image, in the image of God he created him; male and female he created them. God blessed them and said to them, "Be fruitful and increase in number; fill the earth and subdue it. Rule over the fish of the sea and the birds of the air and over every living creature that moves on the ground" (Genesis 1:26–28, NIV).

In front of National Cathedral, Washington, D.C.

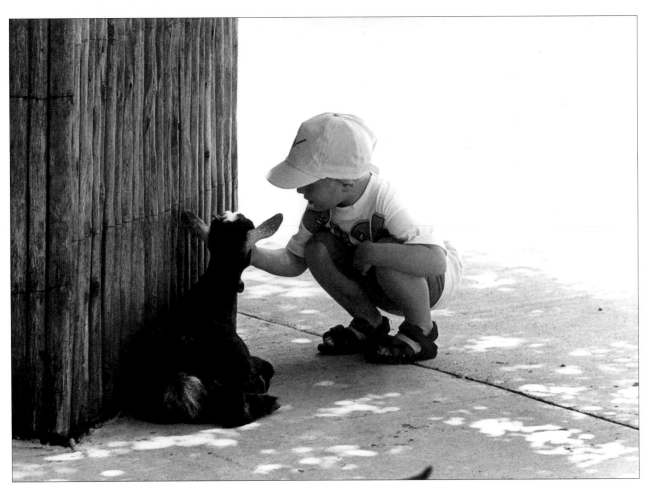

Milwaukee County Zoo, Milwaukee, Wisconsin

Mount Vernon, Virginia

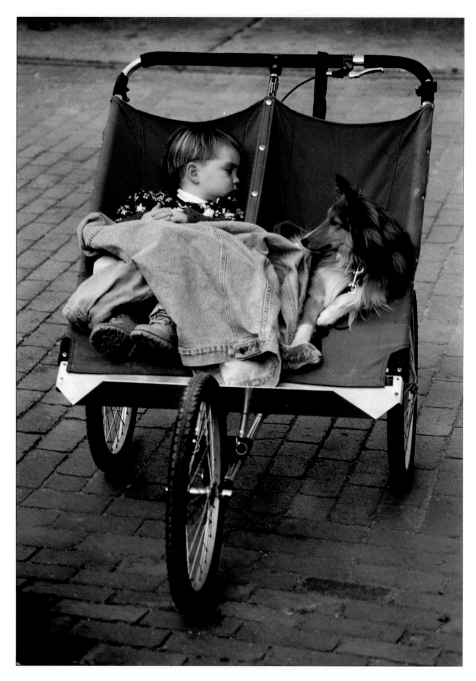

Mount Vernon, Virginia

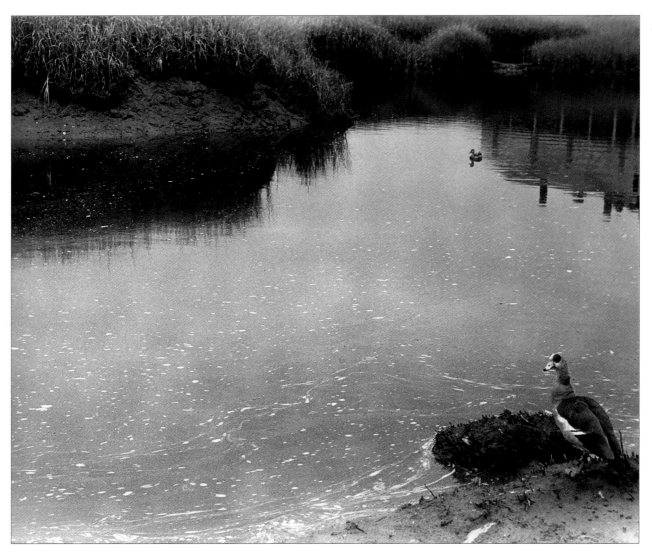

Essex, Massachusetts

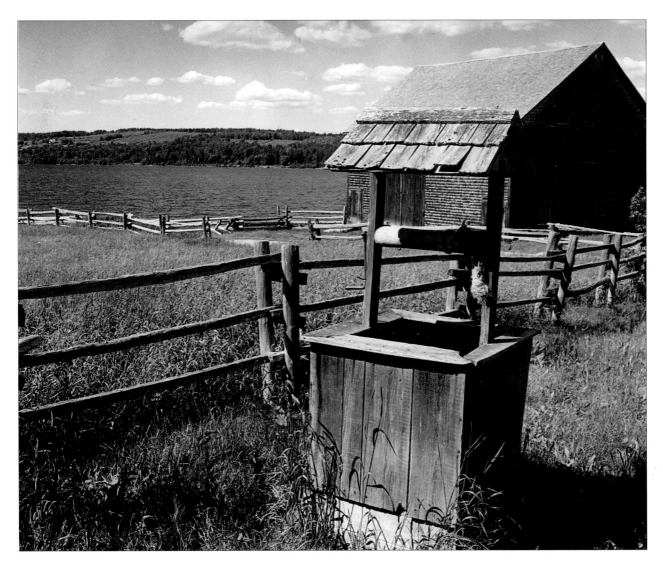

Acadian Historical Village, New Brunswick

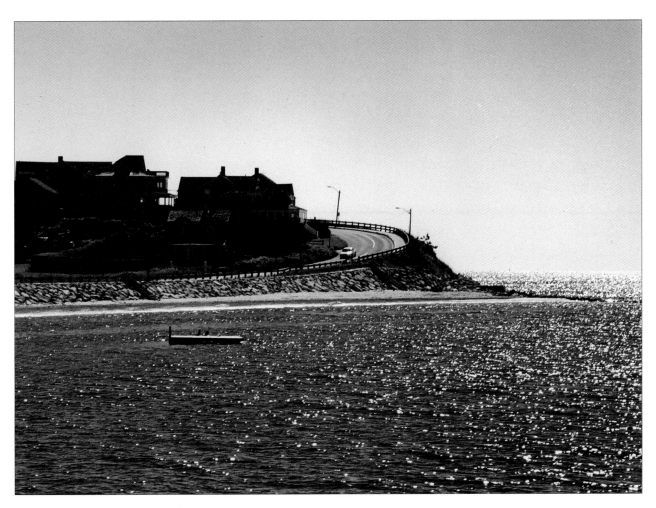

Falmouth Heights, Massachusetts

O Lord, our Lord, how majestic is your name in all the earth!

You have set your glory above the heavens. From the lips of children and infants you have ordained praise because of your enemies, to silence the foe and the avenger.

When I consider your heavens, the work of your fingers, the moon and the stars, which you have set in place, what is man that you are mindful of him, the son of man that you care for him? You made him a little lower than the heavenly beings and crowned him with glory and honor.

You made him ruler over the works of your hands; you put everything under his feet: all flocks and herds, and the beasts of the field, the birds of the air, and the fish of the sea, all that swim the paths of the seas.

O Lord, our Lord, how majestic is your name in all the earth (Psalm 8, NIV)!

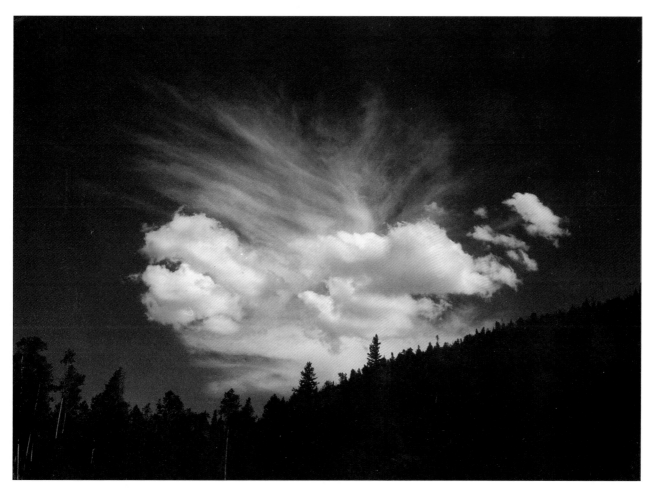

Estes Park, Colorado

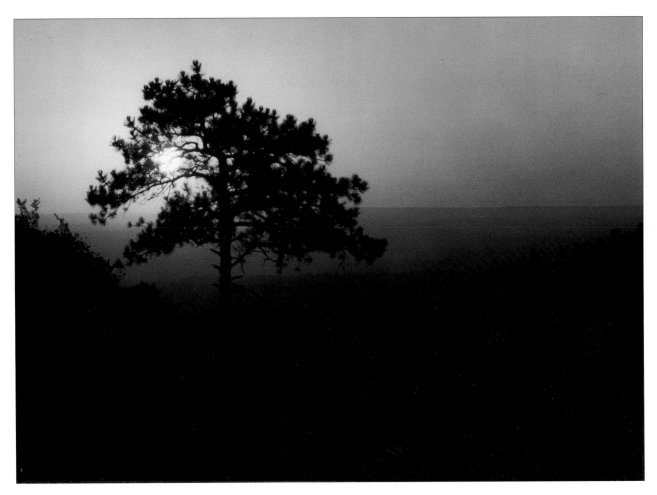

Near base of Pikes Peak, Colorado

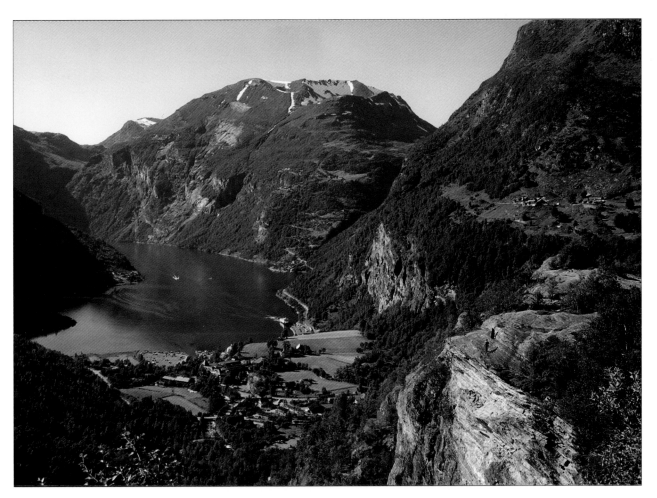

Geirangerfjord, Norway

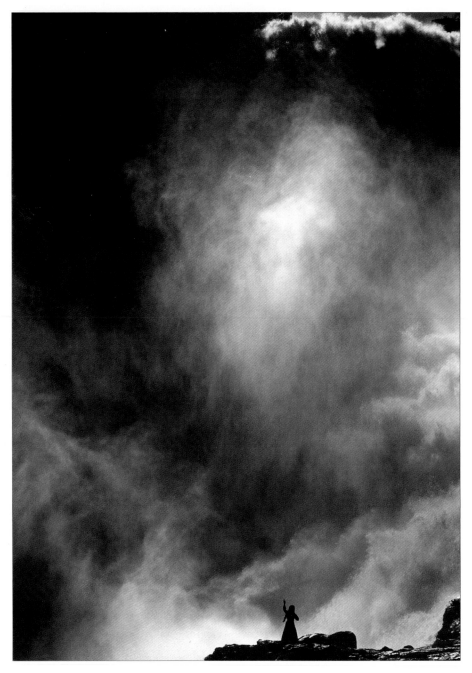

Kjosfossen Waterfall, Norway

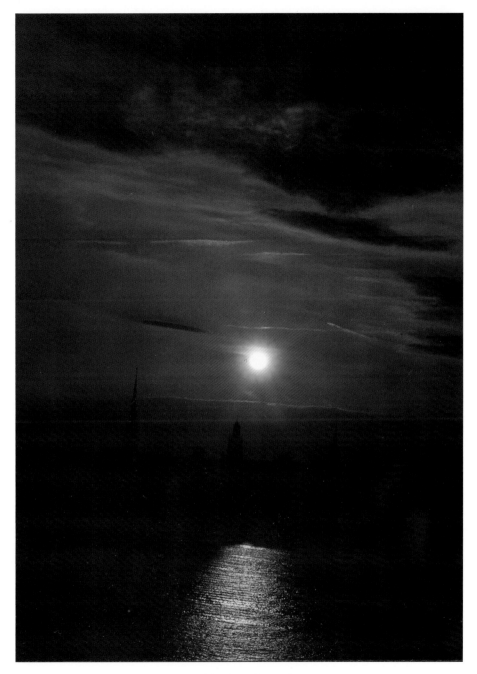

Stockholm, Sweden

The LORD is my shepherd; I shall not want. He makes me to lie down in green pastures; He leads me beside still waters. He restores my soul; He leads me in paths of righteousness for His name's sake.

Yea, though I walk through the valley of the shadow of death, I will fear no evil; for You are with me; Your rod and your staff, they comfort me.

You prepare a table before me in the presence of my enemies; You anoint my head with oil; my cup runs over. Surely goodness and mercy shall follow me all the days of my life; and I will dwell in the house of the LORD forever (Psalm 23, NKJV).

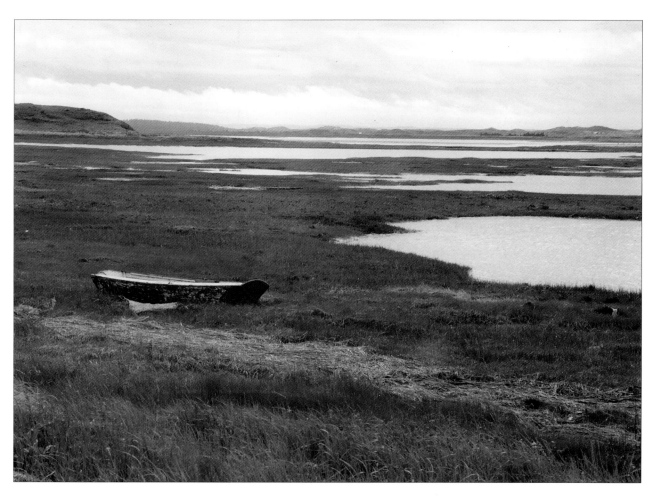

Stanhope by the Sea, Prince Edward Island

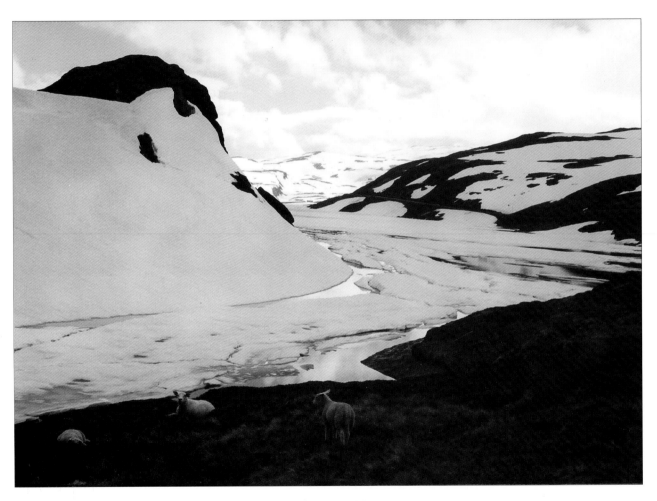

Near Holaseter, Norway

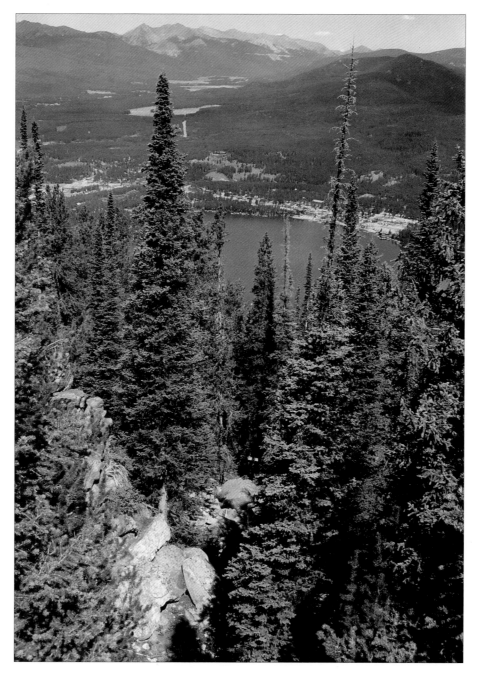

Estes Park, Colorado

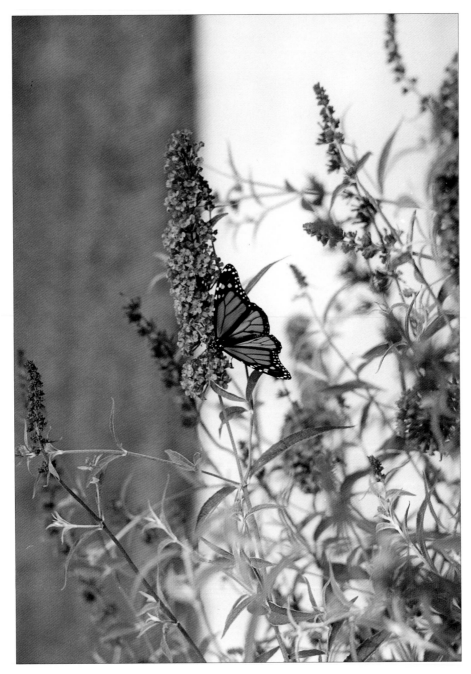

Munsinger Gardens, St. Cloud, Minnesota

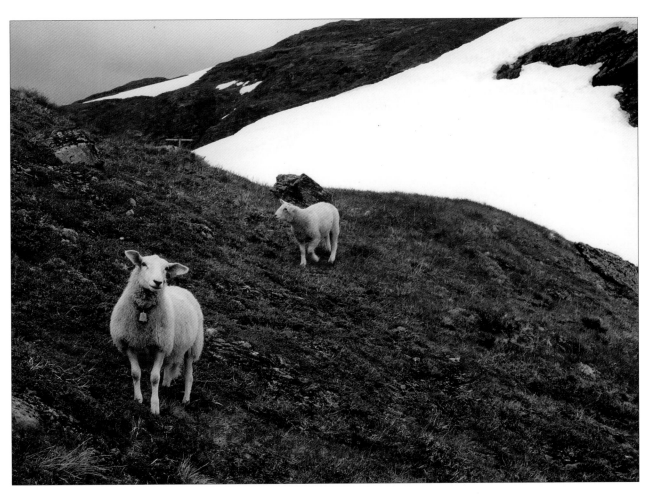

Near Holaseter, Norway

The heavens declare the glory of God; And the firmament shows His handiwork. Day unto day utters speech, And night unto night reveals knowledge. There is no speech nor language where their voice is not heard. Their line has gone out through all the earth, and their words to the end of the world.

In them He has set a tabernacle for the sun, which is like a bridegroom coming out of his chamber, and rejoices like a strong man to run a race. Its rising is from one end of the heaven, and its circuit to the other end; and there is nothing hidden from its heat.

The law of the Lord is perfect, converting the soul; The testimony of the Lord is sure, making wise the simple; The statutes of the Lord are right, rejoicing the heart; The commandment of the Lord is pure, enlightening the eyes; The fear of the Lord is clean, enduring forever; The judgments of the Lord are true and righteous altogether. More to be desired are they than gold, yea, than much fine gold; Sweeter also than honey and the honeycomb. Moreover by them is Your servant warned, and in keeping them there is great reward.

Who can understand his errors? Cleanse me from secret faults. Keep back your servant also from presumptuous sins; let them not have dominion over me. Then I shall be blameless, and I shall be innocent of great transgression. Let the words of my mouth and the meditation of my heart be acceptable in Your sight, O Lord, my strength and my redeemer (Psalm 19, NKJV).

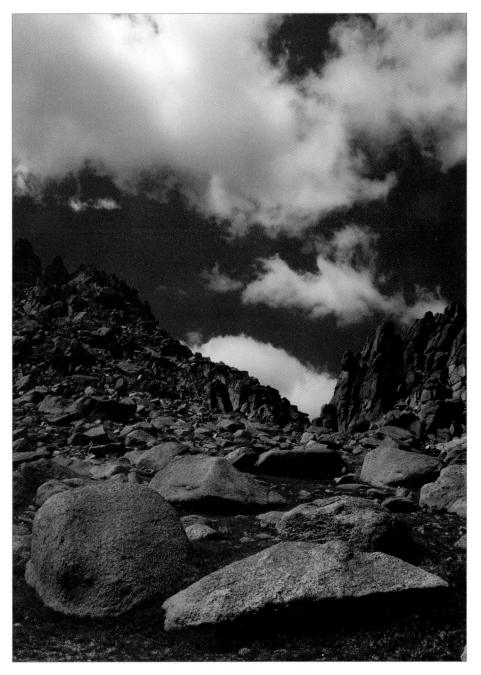

Pikes Peak, Colorado

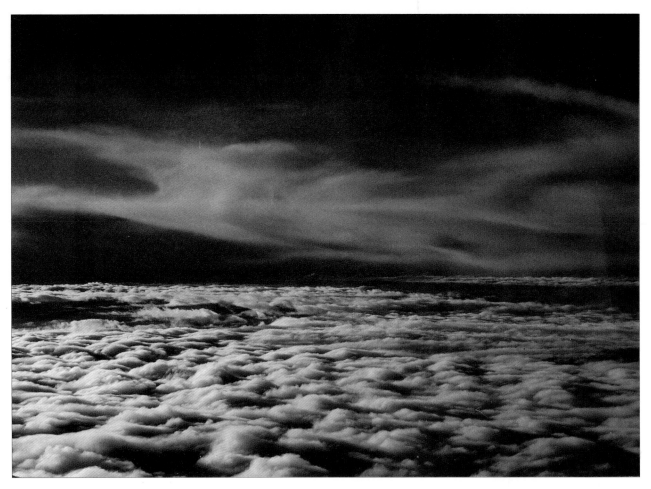

Somewhere in the sky

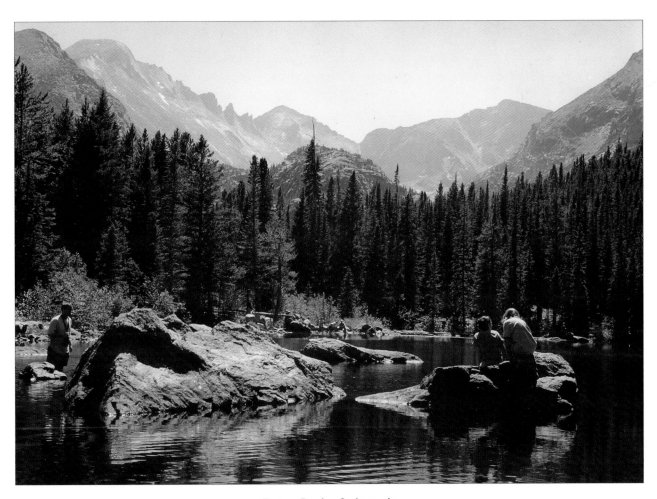

Estes Park, Colorado

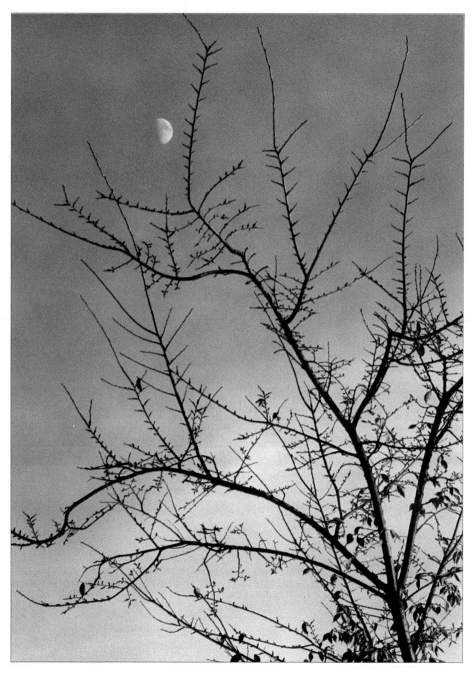

Washington, D.C.

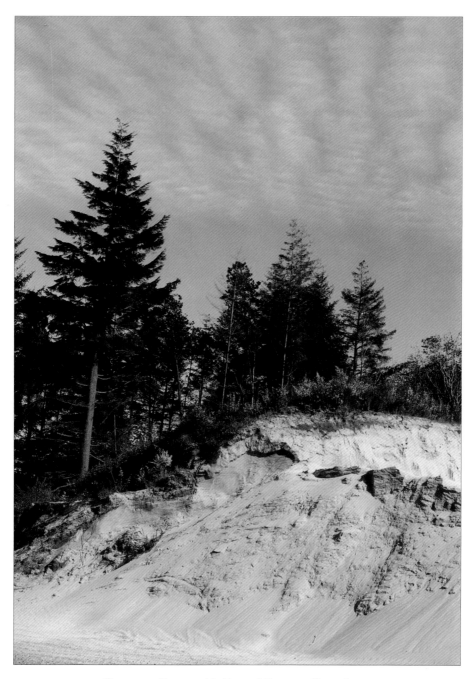

Oregon Dunes National Recreation Area

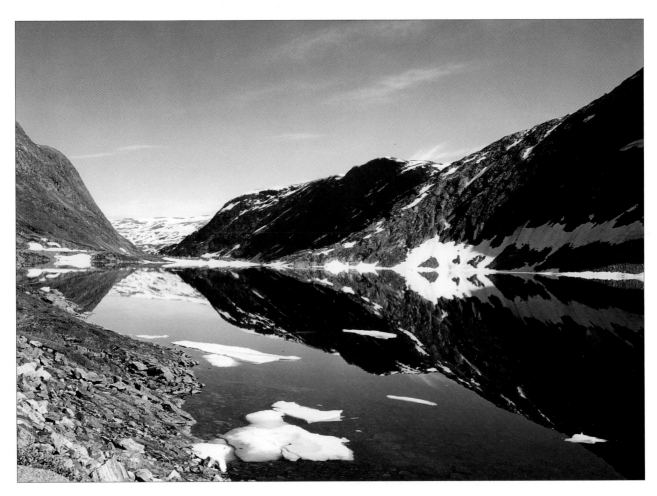

Dalsnibbe Mountains, Norway

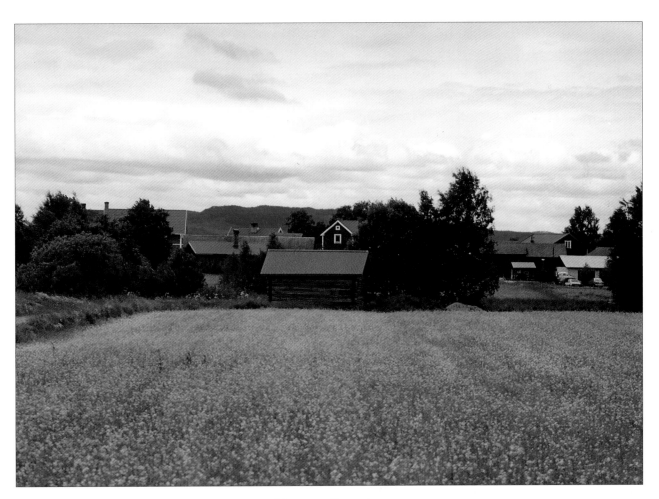

Nusnas, Sweden

G ive thanks to the LORD, for he is good. *His love endures forever.*
Give thanks to the God of gods. *His love endures forever.*
Give thanks to the Lord of lords: *His love endures forever.*
to him who alone does great wonders, *His love endures forever.*
who by his understanding made the heavens, *His love endures forever.*
who spread out the earth upon the waters, *His love endures forever.*
who made the great lights—*His love endures forever.*
the sun to govern the day, *His love endures forever.*
the moon and stars to govern the night; *His love endures forever.*
to him who struck down the firstborn of Egypt *His love endures forever.*
and brought Israel out from among them *His love endures forever.*
with a mighty hand and outstretched arm; *His love endures forever.*
to him who divided the Red Sea asunder *His love endures forever.*
and brought Israel though the midst of it, *His love endures forever.*
but swept Pharaoh and his army into the Red Sea; *His love endures forever.*
to him who led his people through the desert, *His love endures forever.*
who struck down great kings, *His love endures forever.*
and killed mighty kings—*His love endures forever.*
Sihon king of the Amorites *His love endures forever.*
and Og king of Bashan—*His love endures forever.*
and gave their land as an inheritance, *His love endures forever.*
an inheritance to his servant Israel; *His love endures forever.*
to the One who remembered us in our low estate *His love endures forever.*
and freed us from our enemies, *His love endures forever.*
and who gives food to every creature. *His love endures forever.*
Give thanks to the God of heaven. *His love endures forever* (Psalm 136, NIV).

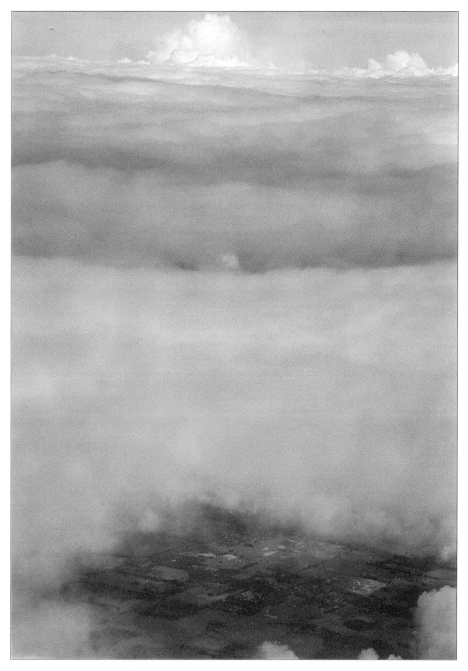

Northern Florida

Moncton, New Brunswick

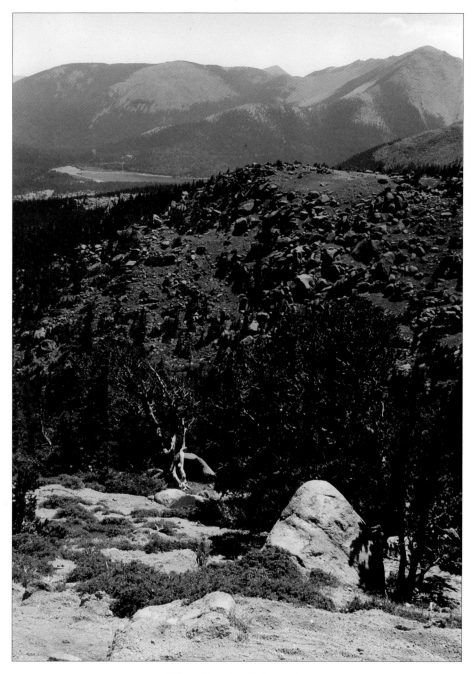

Pikes Peak, Colorado

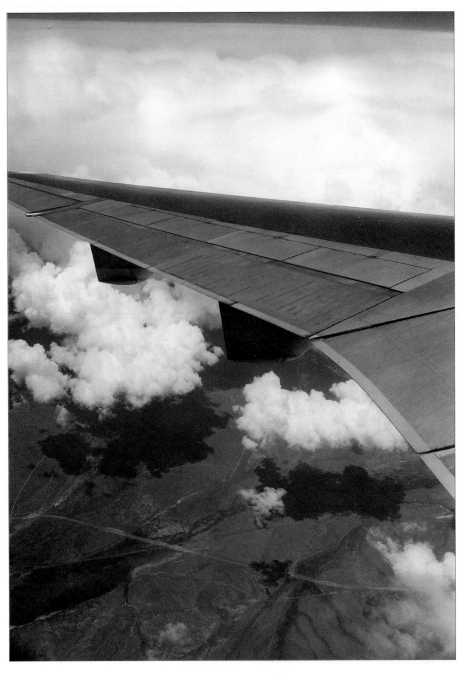

Northern Nevada

PART TWO

HOW HUMAN BEINGS ARE SO EXTRAORDINARY WITHIN THE CREATION

Every once in a while, we see cloud formations that remind us of something here on earth. We never know precisely where or when these formations will occur, but we can be certain that we will see another familiar figure in the sky someday. All we need is to keep looking up and to keep remembering what we've seen on earth. Everyone who has good eyesight is able to make these observations.

Familiar-looking cloud formations represent a very basic form of human knowledge. When one thing looks like another, we can be sure that the two things are of the same kind unless there are significant distinguishing characteristics between the two. For example, when one thing is white and in the sky, and the other is not white and in the back yard, we know that the two similar-looking things cannot truly be the same. Even when both of the similar-looking creatures are in the back yard, they can be distinguished by size and color.

Discriminating between one item and another is a task that is performed with ease by people throughout the world. From infancy, when we first distinguish ourselves from our mothers, until the end of our lives, it is evident that the ability to discriminate is innate in all of us. It is not, however, natural for us to love some things and hate others based solely on physical appearance.

Our tendency to love some things and hate others is innate, but this tendency, more specifically, is to love what is morally good and hate what is morally bad. We are not like the predators of the animal kingdom, naturally devouring whatever creatures we can overpower. However, humans can become like predators. Hitler is the most extreme example of this horrendous human capacity at work. But the overpowering of a defenseless human being by others is not natural. It comes from either a reversal or a distortion of what is morally good and what is morally bad in the mind of the violator.

No animal can be as horrifyingly deceptive and cruel as a person can, and no animal can be as compassionate, loving, and just as a person. The only thing that fully separates the actions of human beings from the actions of animals is the moral base from which each human being makes choices.

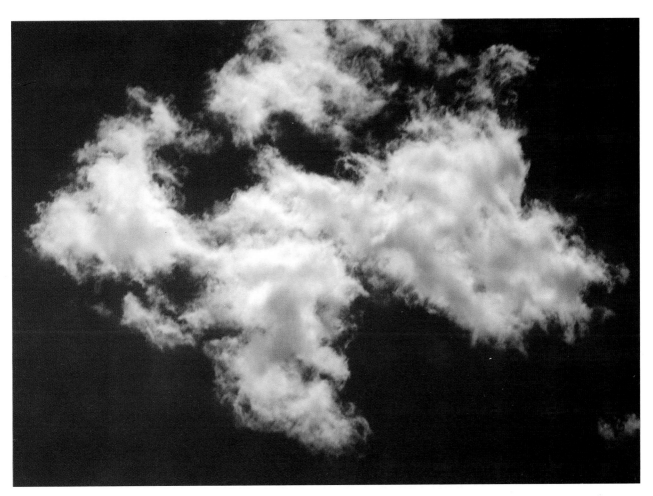

Do you see the dog shape in this cloud?

Do you see the irony in this picture? This small black bird is in the presence of what may be its god—the god of the birds by whom all birds were lovingly created and to whom all birds are accountable—and it does not appear to be the least bit overwhelmed. Sure, this is only a statue. If the black bird were to approach the big bald eagle in the sky, things might be different.

Of course, the statue is not the bird's god, and it does not even represent the bird's god. The black bird does not have to ponder whether its thoughts and actions are morally good or bad, because birds are not moral beings.

We humans, on the other hand, are moral beings. Our inevitable tendency to recognize things as being morally good or bad indicates that both moral good and moral bad exist. Our desire to do what is morally good indicates that good and bad are not equal. Any attempt to call a morally good action bad or a bad action good represents a distorted view of our predicament as human beings.

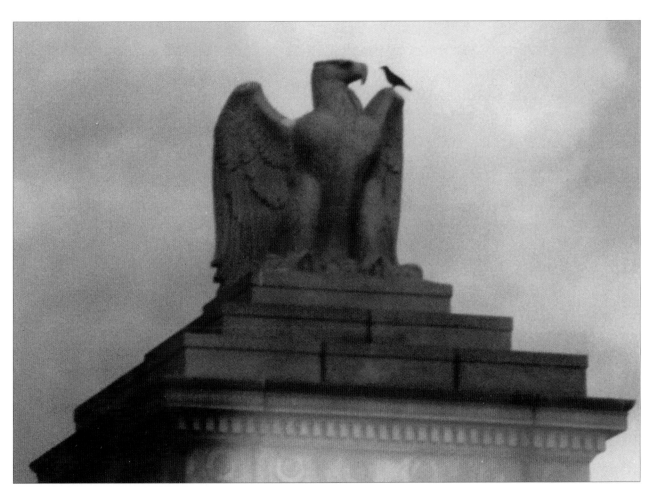

Washington, D.C.

To everything there is a season, a time for every purpose under heaven:
A time to be born, and a time to die;
A time to plant, and a time to pluck what is planted;
A time to kill, and a time to heal;
A time to break down, and a time to build up;
A time to weep, and a time to laugh;
A time to mourn, and a time to dance;
A time to cast away stones, and a time to gather stones;
A time to embrace, and a time to refrain from embracing;
A time to gain, and a time to lose;
A time to keep, and a time to throw away;
A time to tear, and a time to sew;
A time to keep silence, and a time to speak;
A time to love, and a time to hate;
A time of war, and a time of peace.

What profit has the worker from that in which he labors? I have seen the God-given task with which the sons of men are to be occupied. He has made everything beautiful in its time. Also He has put eternity in their hearts, except that no one can find out the work that God does from beginning to end (Ecclesiates 3:1–11, NKJV).

Mount Vernon, Virginia

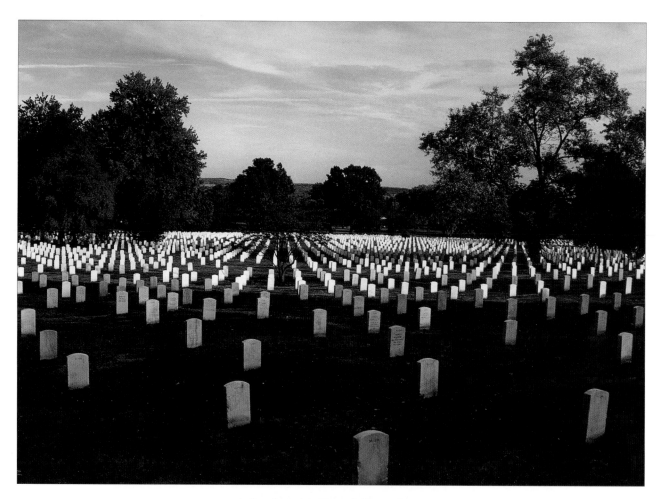

Arlington National Cemetery

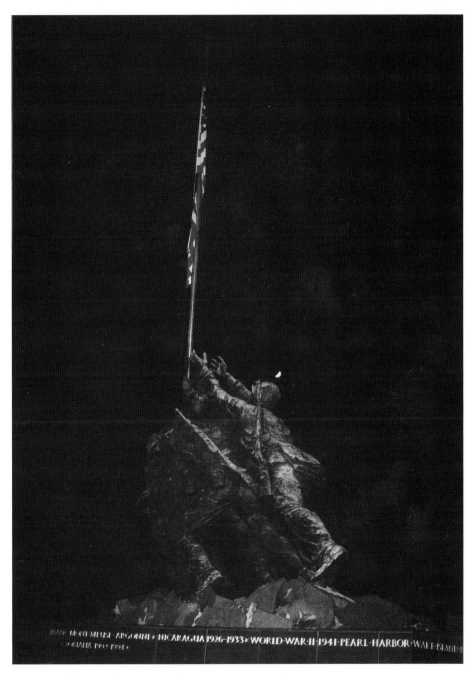

Iwo Jima Memorial, Washington, D.C.

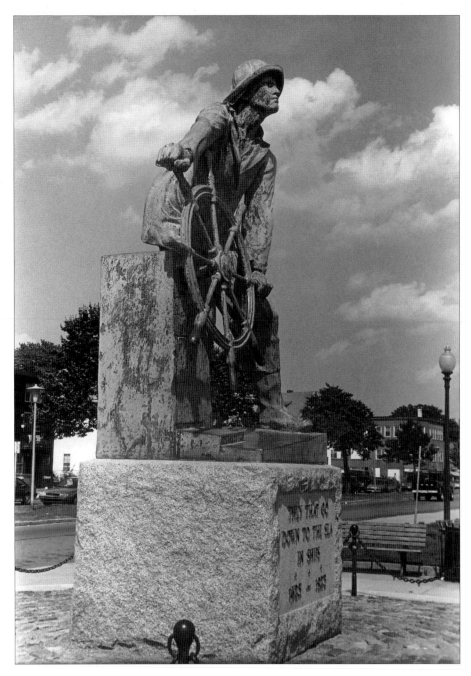

Fisherman Statue, Gloucester, Massachusetts

Garden of the Gods, Colorado Springs, Colorado

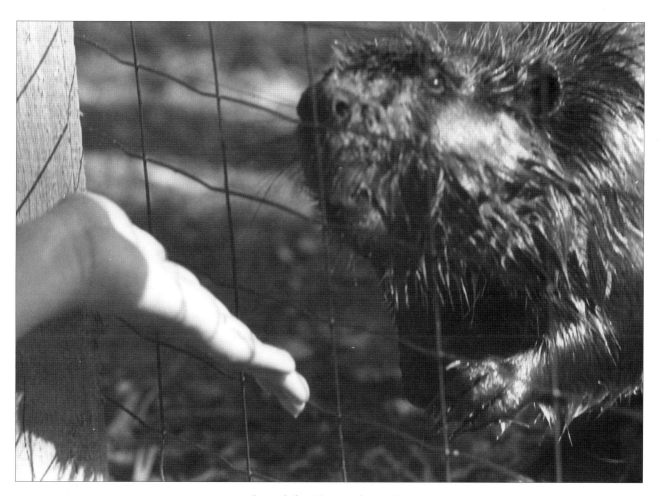

Ipswich, Massachusetts

Your statutes are wonderful; therefore I obey them. The entrance of your words gives light; it gives understanding to the simple. I open my mouth and pant, longing for your commands. Turn to me and have mercy on me, as you always do to those who love your name. Direct my footsteps according to your word; let no sin rule over me. Redeem me from the oppression of men, that I may obey your precepts. Make your face shine upon your servant and teach me your decrees. Streams of tears flow from my eyes, for your law is not obeyed (Psalm 119:129–136, NIV).

Marshall, Texas

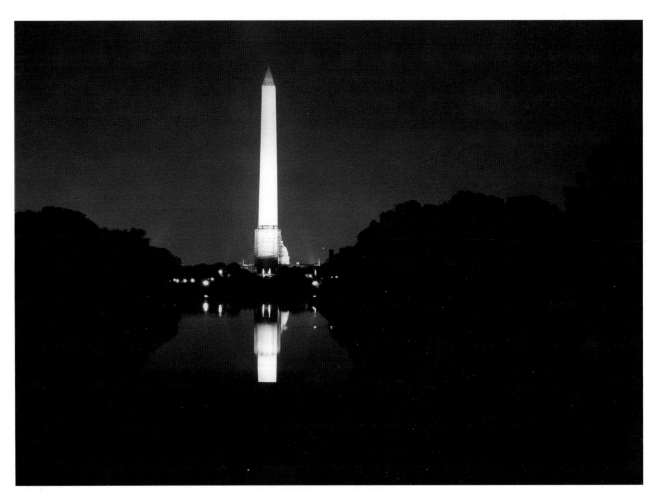

Washington Monument

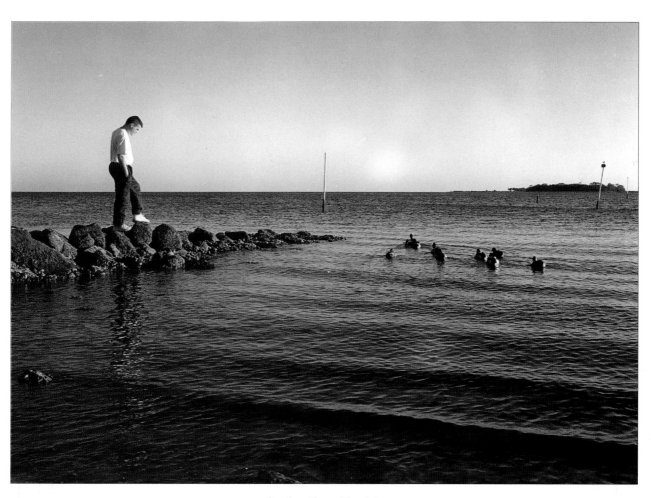

Cedar Key, Florida

The Lord is my light and my salvation—whom shall I fear? The Lord is the stronghold of my life—of whom shall I be afraid? When evil men advance against me to devour my flesh, when my enemies and my foes attack me, they will stumble and fall. Though an army besiege me, my heart will not fear; though war break out against me, even then I will be confident.

One thing I ask of the Lord, this is what I seek: that I may dwell in the house of the Lord all the days of my life, to gaze upon the beauty of the Lord and to seek him in his temple. For in the day of trouble he will keep me safe in his dwelling; he will hide me in the shelter of his tabernacle and set me high upon a rock.

Then my head will be exalted above the enemies who surround me; at his tabernacle will I sacrifice with shouts of joy; I will sing and make music to the Lord. Hear my voice when I call, O Lord; be merciful to me and answer me. My heart says of you, "Seek his face!"

Your face, Lord, I will seek. Do not hide your face from me, do not turn your servant away in anger; you have been my helper. Do not reject me or forsake me, O God my Savior. Though my father and mother forsake me, the Lord will receive me. Teach me your way, O Lord; lead me in a straight path because of my oppressors. Do not turn me over to the desire of my foes, for false witnesses rise up against me, breathing out violence.

I am still confident of this: I will see the goodness of the Lord in the land of the living. Wait for the Lord; be strong and take heart and wait for the Lord (Psalm 27, NIV).

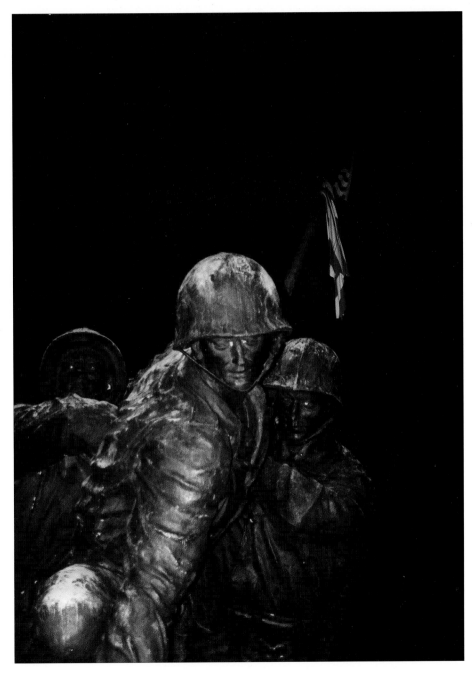

Iwo Jima Memorial, Washington, D.C.

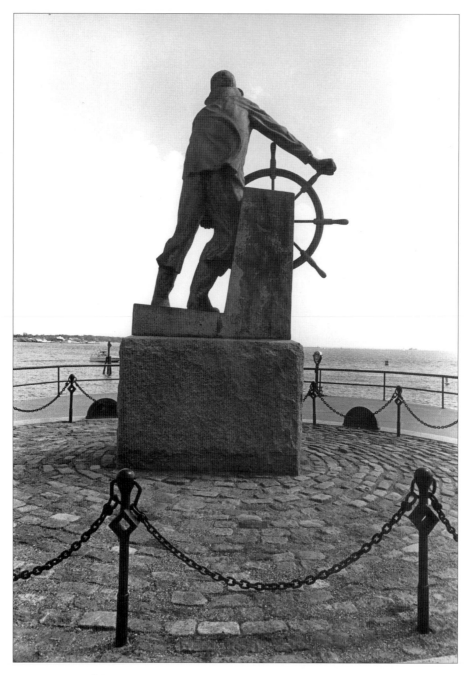

Fisherman Statue, Gloucester, Massachusetts

PART THREE

HOW IT MAKES SENSE

So we are moral beings who love the same beauty that the Creator loves. But how do we make sense of it? Where does our moral nature come from? I propose that it comes from the same place that our love for beauty comes from: our Creator. Our Creator, like us, is moral by nature. We love what is good and hate what is bad because our Creator loves what is good and hates what is bad. Yet we continually disagree among ourselves concerning precisely what is good and what is bad. Where does this confusion come from? It can't come directly from the Creator. A moral Creator who created moral beings must know what is good and what is bad. Otherwise, He would either not be moral or not be the Creator. Furthermore, the Creator must be completely good, because good and bad necessarily conflict. The one God who created all things must necessarily be totally good, and evil must be the product of a rebellion from within the creation. The specific conflict, which indicates a rebellion from within the creation, is this: We human beings cannot agree concerning which actions are good and which actions are bad, yet we know that there is evil among us.

The rebellion, which is necessarily the source of our difficult human predicament, is sufficiently explained in the Bible. But the answer to the equally important question, "Rebellion from what?" is found there as well. God, the Creator, experienced perfect relationship from the beginning. He has always existed in three Persons—the Father, the Son, and the Holy Spirit, commonly known as the Trinity. These three, each being one and the same God, have always experienced perfect relationship. God created angels, and before Adam and Eve sinned, one-third of the angels, led by Satan, rebelled against God. In doing so, they exercised their free will in a terrible way, choosing to become the first creatures to do what is bad rather than what is good.

When God created Adam and Eve, He took a huge risk by giving them a free will. They could choose either to experience intimacy with their Creator or to reject it. Ever since Adam and Eve were deceived by Satan and sinned for the first time, they and all of their descendants have had a severed relationship with their Creator.

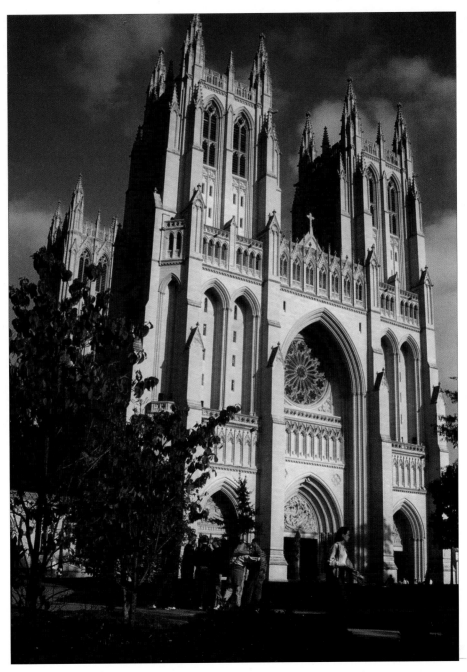

National Cathedral, Washington, D.C.

But God has continued to pursue the human beings that He has created. He wants us to freely choose to love Him, and He has made the greatest possible sacrifice so that we can understand how much He loves us and how great a Creator He is. Jesus Christ, the Creator and the Son from the Trinity, chose to become a humble, poor Jewish man who did not have a home. Jesus showed us what perfect love and compassion is like through His encounters with everyone He met. He came to earth to become the sacrifice that is needed in order for us to experience the intimacy that He longs to have with us. Our moral fallenness is what separates us from our Creator, and that fallenness makes us deserving of death. But through God's grace, shown by the death and resurrection of Jesus Christ, our moral fallenness is atoned for, and we are able to experience intimacy with our Creator. All that we need is to believe in the love that our Creator has for us, and to accept that love on God's terms through Jesus Christ. God is merciful. No person is morally good enough to experience intimacy with God. That would require perfection. Intimacy with God requires God's mercy. He loves to forgive us, but He cannot go against His morally good, holy nature. This is why salvation comes only through Jesus Christ, the Creator and the Son from the Trinity. The mercy that restores us to intimacy with our Creator has to come directly from our Creator. Mercy from any other source will not suffice. And don't be afraid; God's mercy never ends.

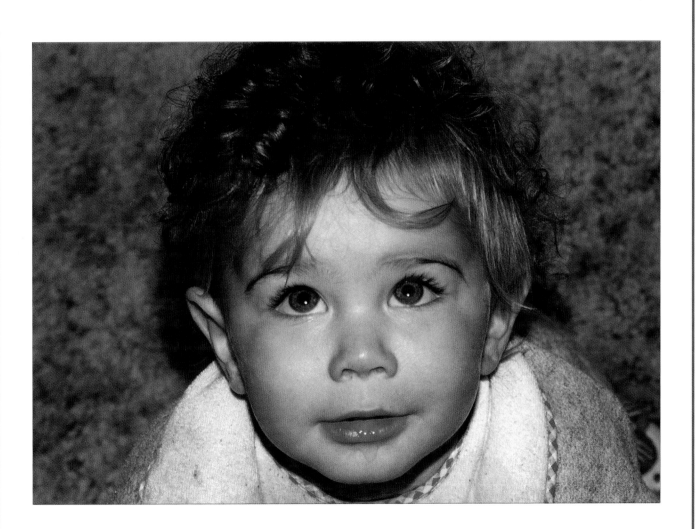

And this is the testimony: that God has given us eternal life, and this life is in His Son. He who has the Son has life; he who does not have the Son of God does not have life (1 John 5:11–12, NKJV).

I am the door. If anyone enters by Me, he will be saved, and will go in and out and find pasture. The thief does not come except to steal, and to kill, and to destroy. I have come that they may have life, and that they may have it more abundantly (John 10:9–10, NKJV).

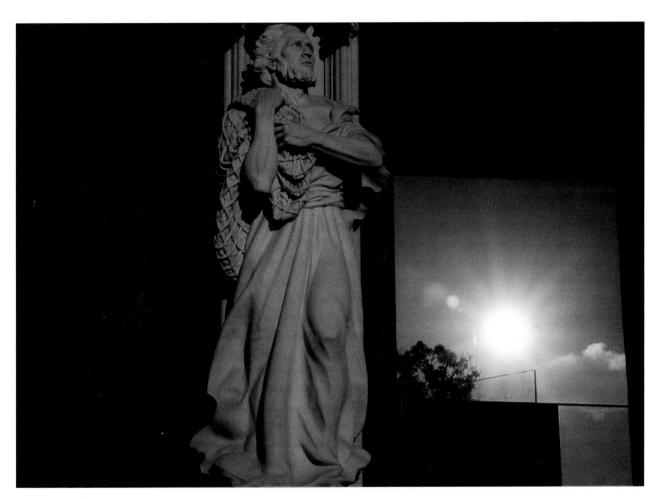

National Cathedral, Washington, D.C.

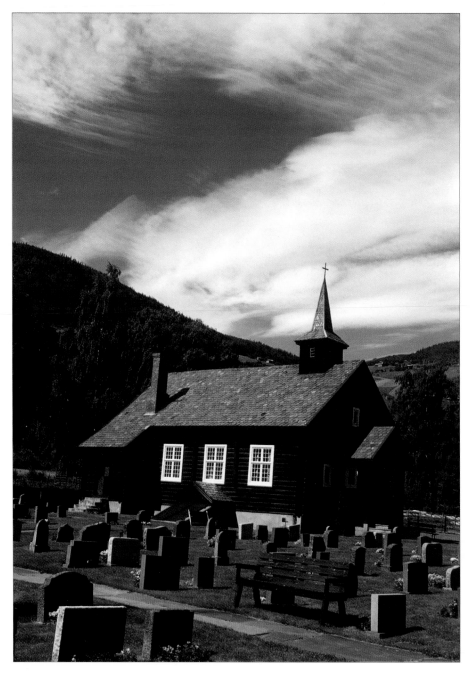

A stave church in rural Norway

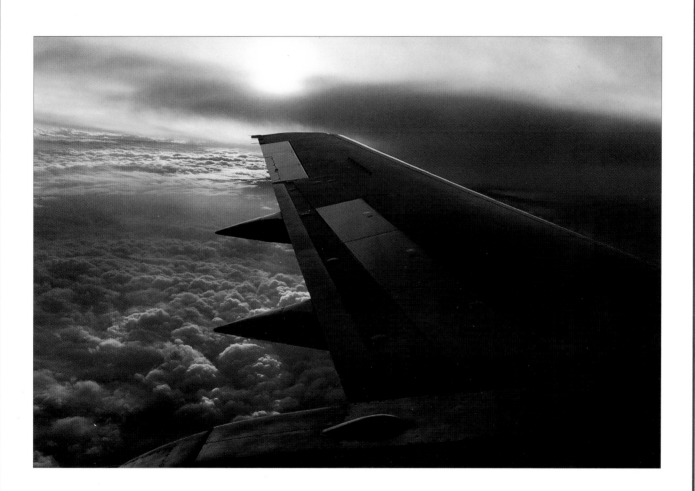

People were bringing little children to Jesus to have him touch them, but the disciples rebuked them. When Jesus saw this, he was indignant. He said to them, "Let the little children come to me, and do not hinder them, for the kingdom of God belongs to such as these. I tell you the truth, anyone who will not receive the kingdom of God like a little child will never enter it." And he took the children in his arms, put his hands on them and blessed them (Mark 10:13–16, NIV).

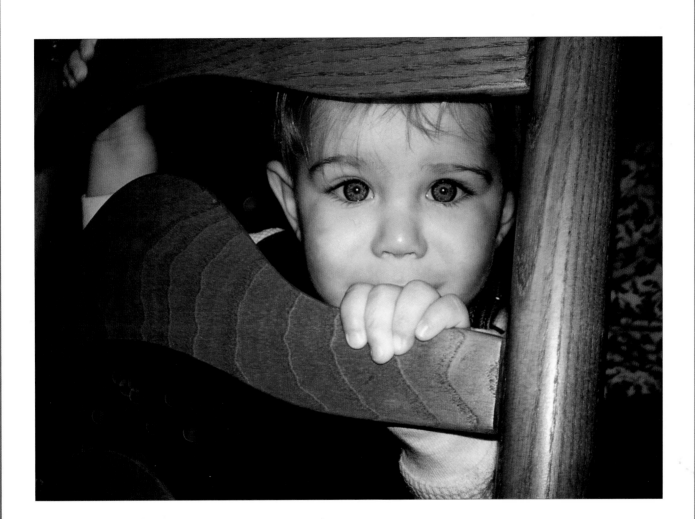

He has showed you, O man, what is good. And what does the LORD require of you? To act justly and to love mercy and to walk humbly with your God (Micah 6:8, NIV).

Blessed are the merciful, for they will be shown mercy (Matthew 5:7, NIV).

Do not think that I have come to abolish the Law or the Prophets; I have not come to abolish them but to fulfill them. I tell you the truth, until heaven and earth disappear, not the smallest letter, not the least stroke of a pen, will by any means disappear from the law until everything is accomplished (Matthew 5:17–18, NIV).

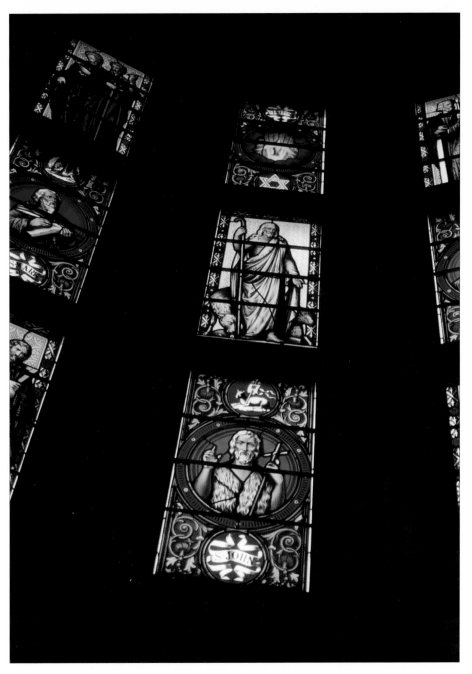

Cathedral at the University of Stockholm

B lessed are those who mourn, for they will be comforted (Matthew 5:4, NIV).

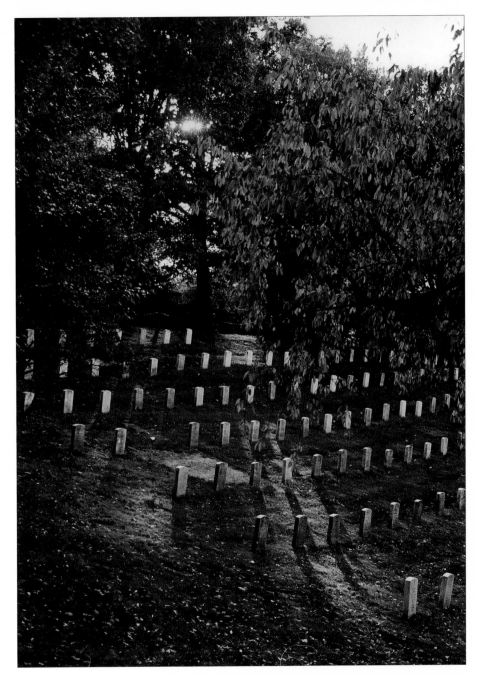

Arlington National Cemetery

As he went along, people spread their cloaks on the road. When he came near the place where the road goes down the Mount of Olives, the whole crowd of disciples began joyfully to praise God in loud voices for all the miracles they had seen:

"Blessed is the king who comes in the name of the Lord!"

"Peace in heaven and glory in the highest!"

Some of the Pharisees in the crowd said to Jesus, "Teacher, rebuke your disciples!"

"I tell you," he replied, "if they keep quiet, the stones will cry out" (Luke 19:36–40, NIV).

Garden of the Gods, Colorado Springs, Colorado

To order additional copies of

The Big Picture

have your credit card ready and call

(877) 421-READ (7323)

or send $19.95 each + $3.95* S&H to

WinePress Publishing
PO Box 428
Enumclaw, WA 98022

* add $1.00 for each additional book ordered